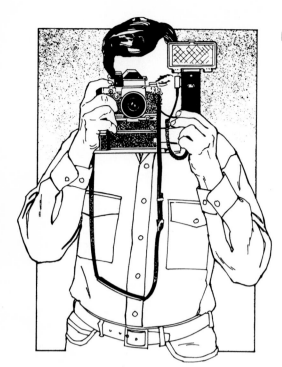

Photographer

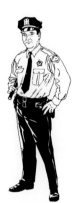

Police officer (street)

Backhoe operator

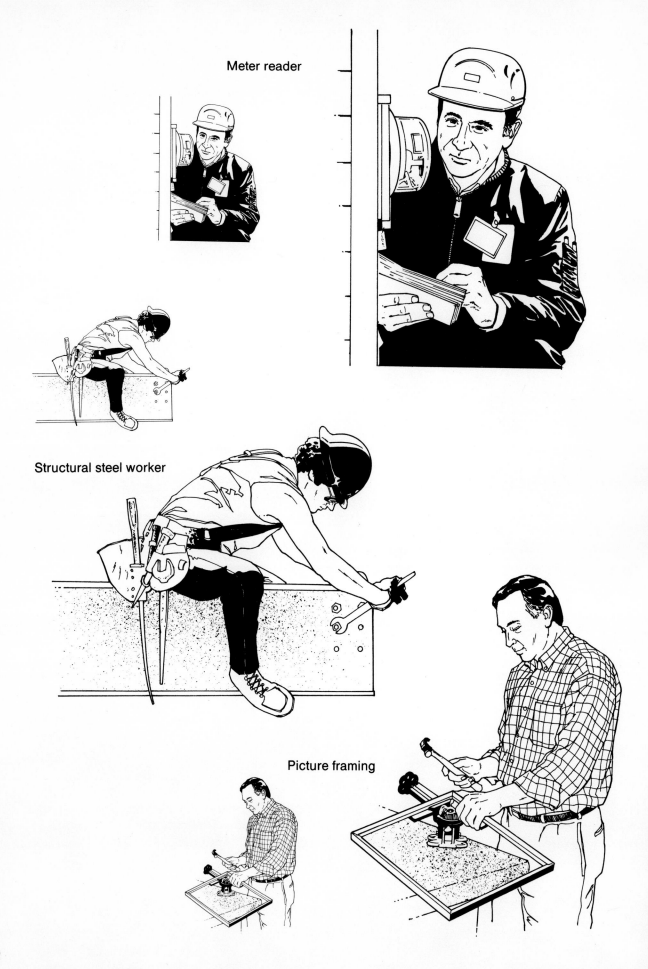

Meter reader

Structural steel worker

Picture framing

2

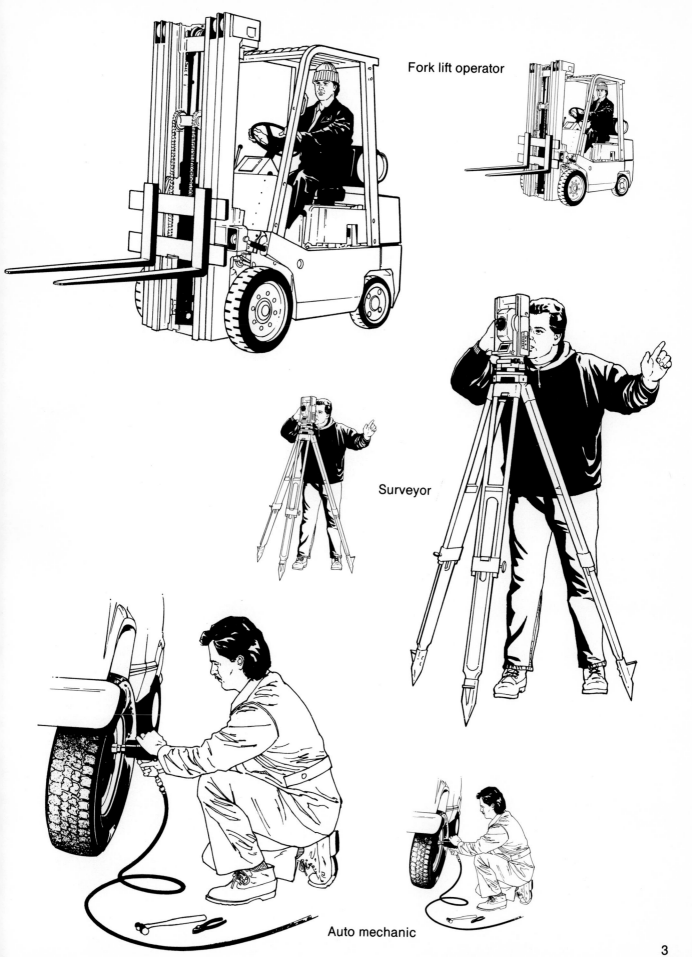

Fork lift operator

Surveyor

Auto mechanic

Police officer (traffic)

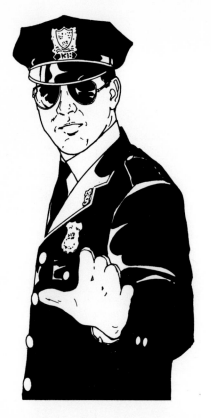

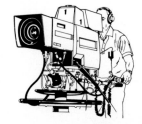

TV studio cameraman

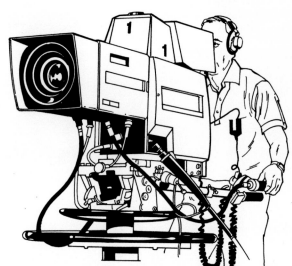

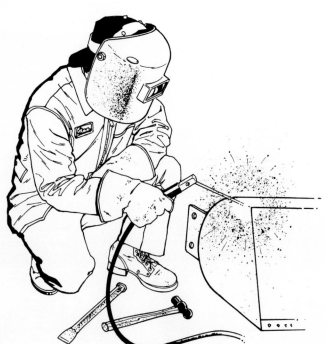

Arc welder

Chef

Auctioneer

Oil rig workers

Seamstress

Carpet cleaning

Front-end loader

6

Dishwasher

Jackhammer operator

Bicycle repair

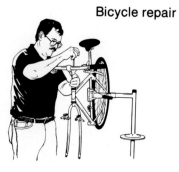

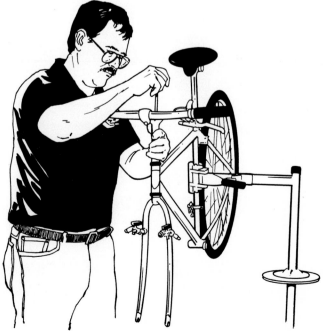

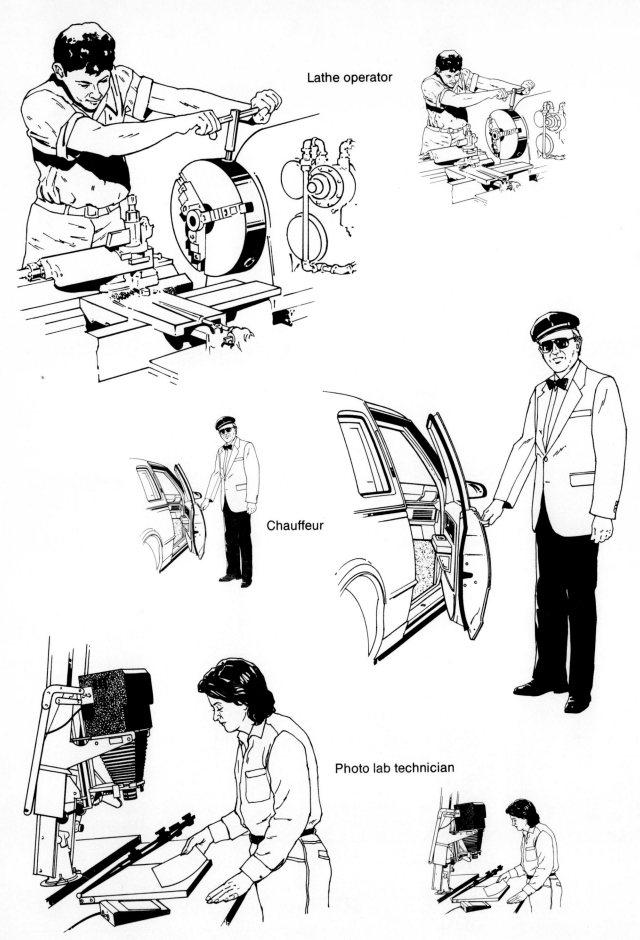

Lathe operator

Chauffeur

Photo lab technician

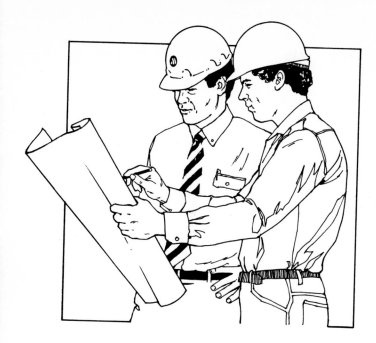

Construction engineers

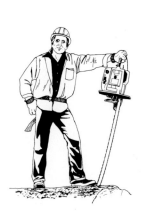
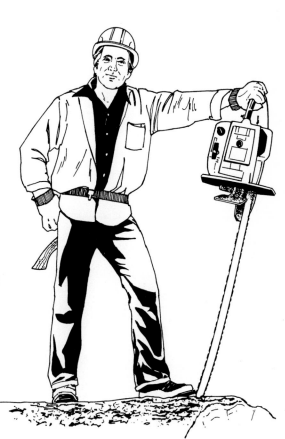

Lumberjack

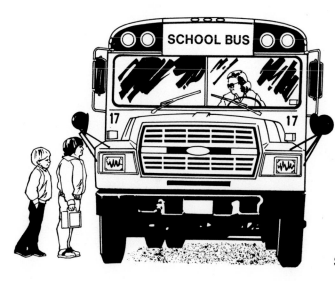

School bus driver

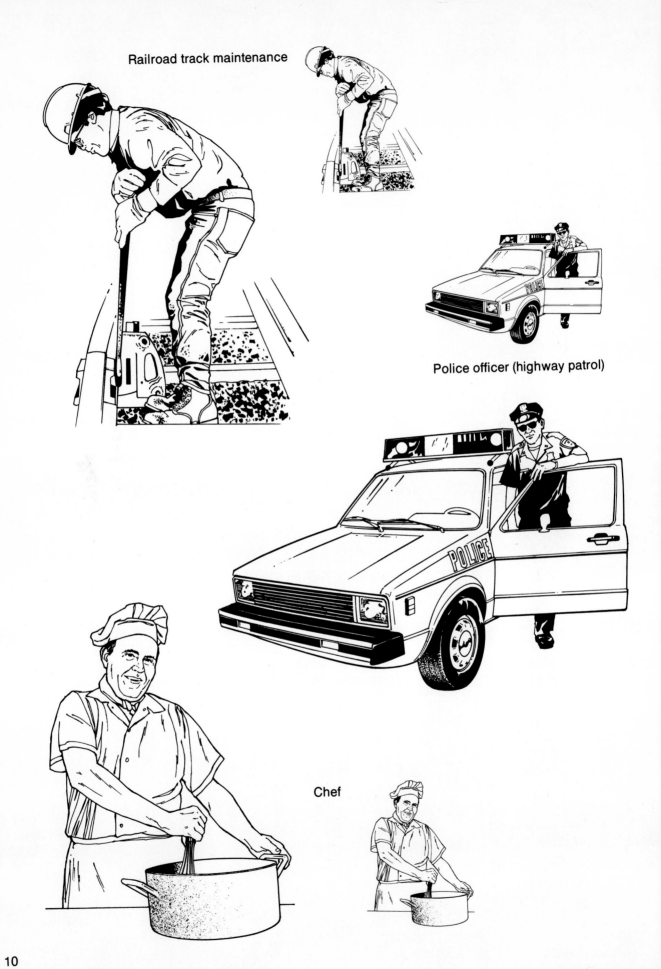

Railroad track maintenance

Police officer (highway patrol)

Chef

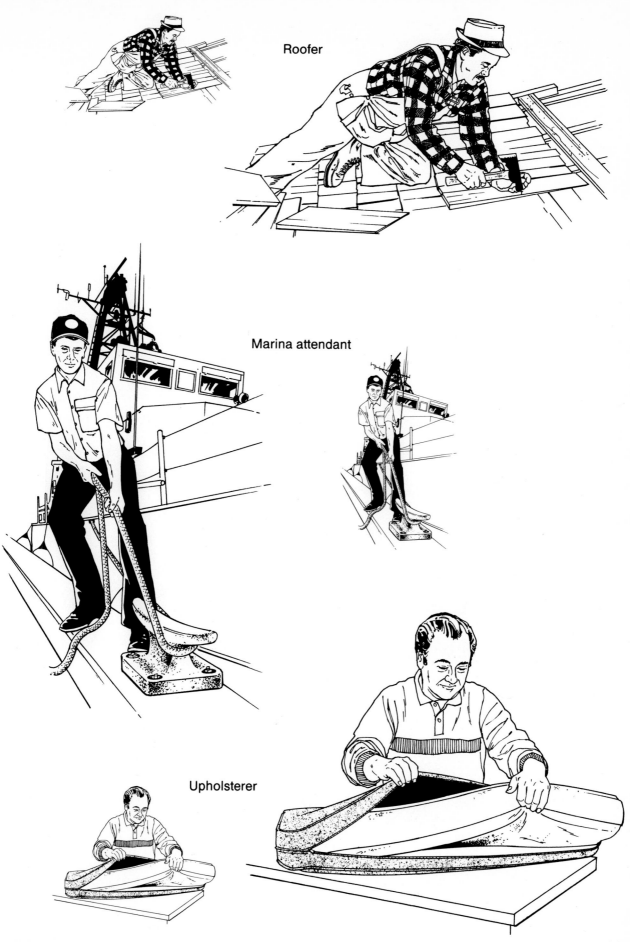

Roofer

Marina attendant

Upholsterer

11

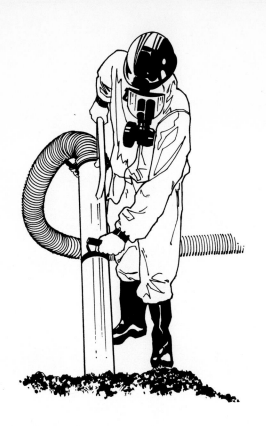

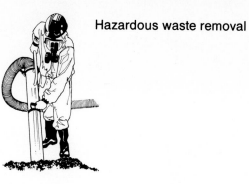

Hazardous waste removal

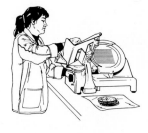

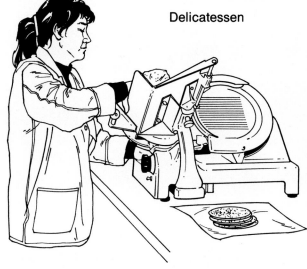

Delicatessen

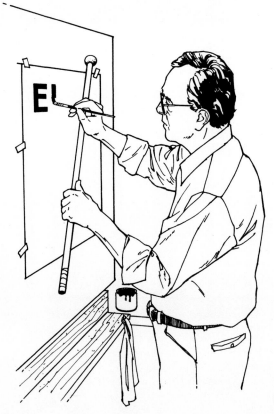

Sign painter

Air conditioner repair

Florist

Fisherman

13

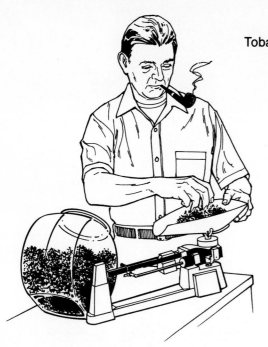

Tobacconist

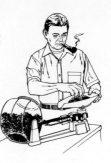

Landscaper

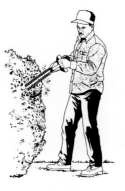

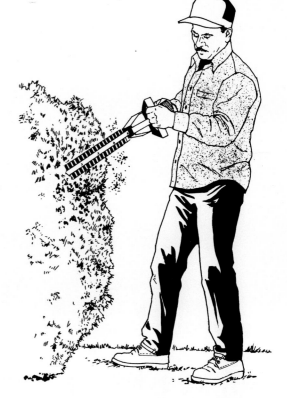

Electronics repair

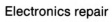

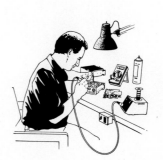

Aircraft maintenance

Bartender

Camera repair

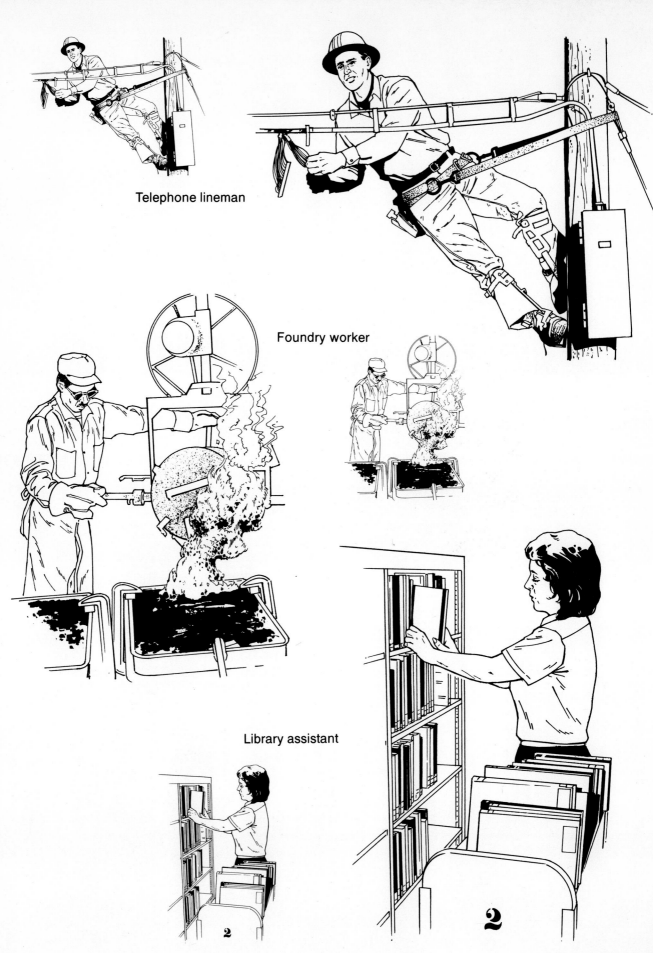

Telephone lineman

Foundry worker

Library assistant

2

2

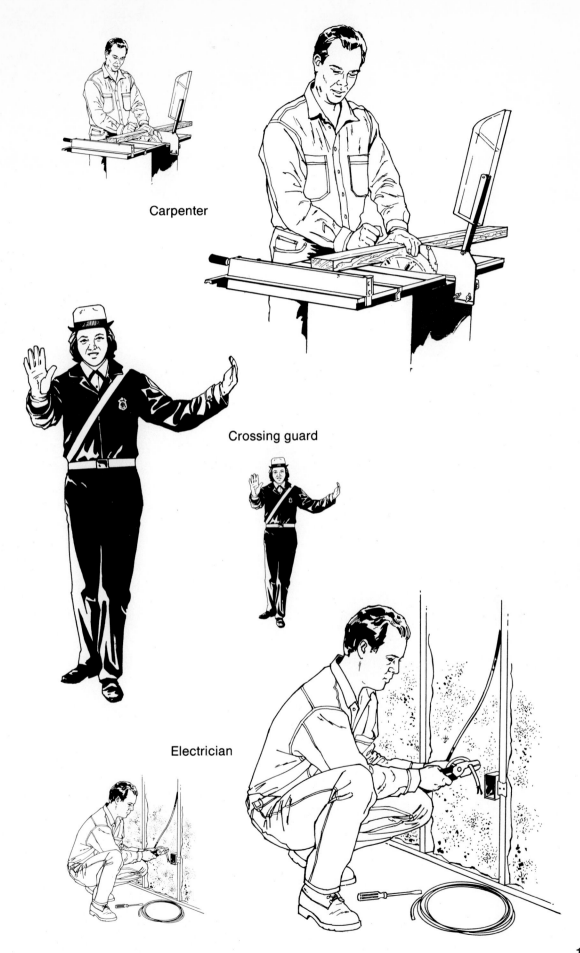

Carpenter

Crossing guard

Electrician

17

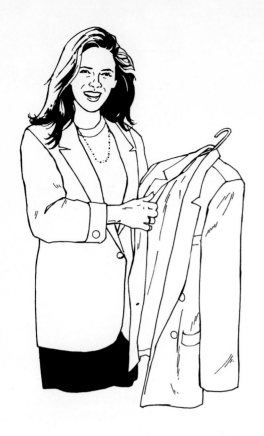

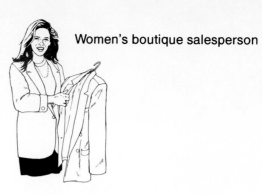

Women's boutique salesperson

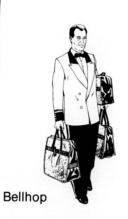

Bellhop

Telephone switchboard operator

18

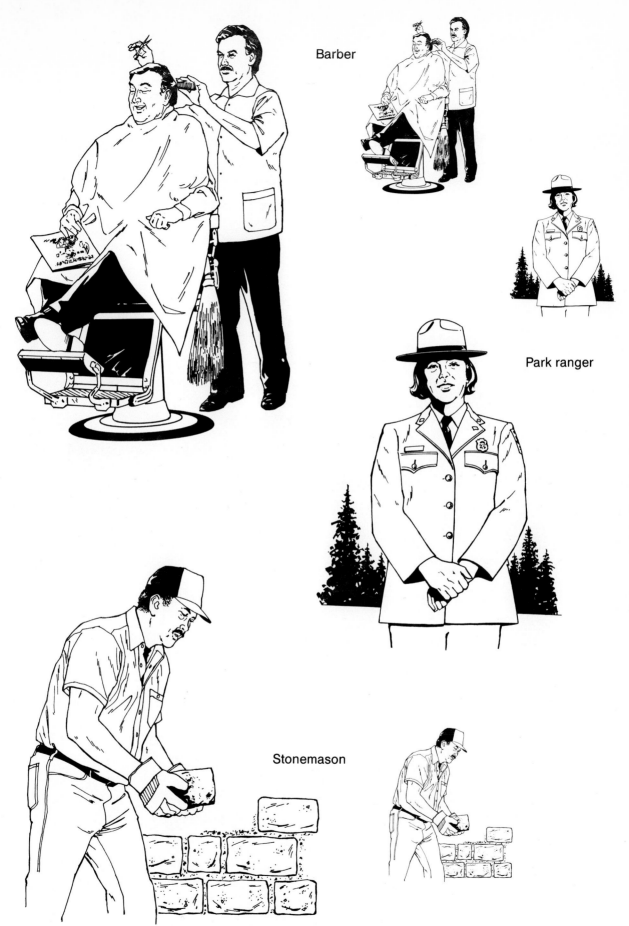

Barber

Park ranger

Stonemason

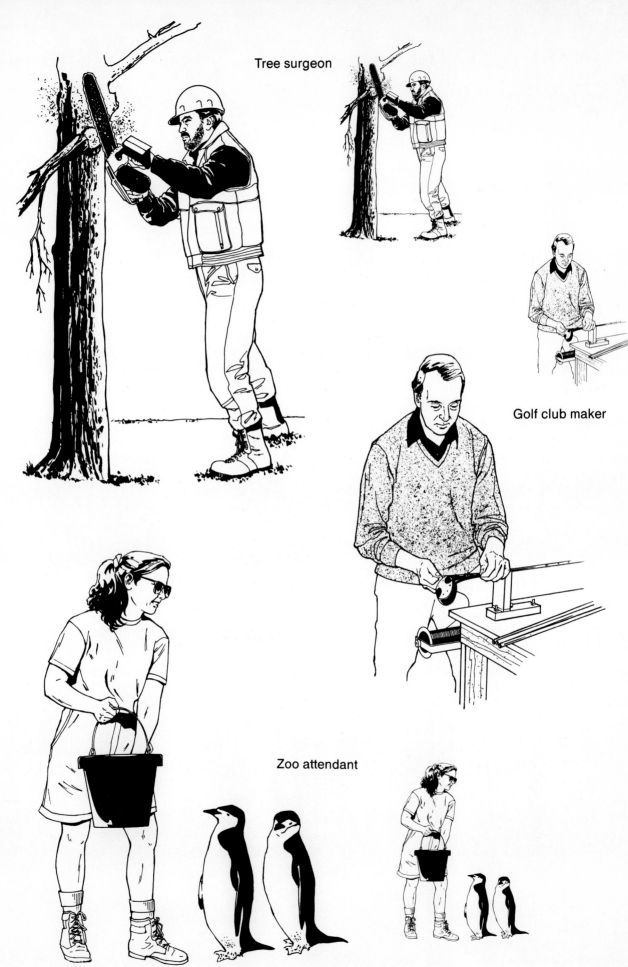

Tree surgeon

Golf club maker

Zoo attendant

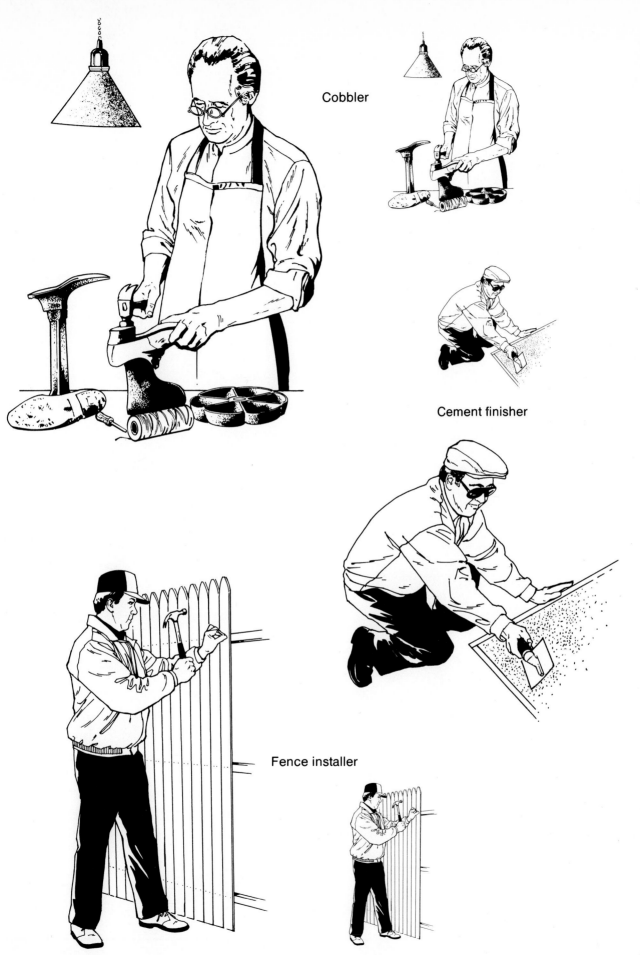

Cobbler

Cement finisher

Fence installer

Gas station attendant

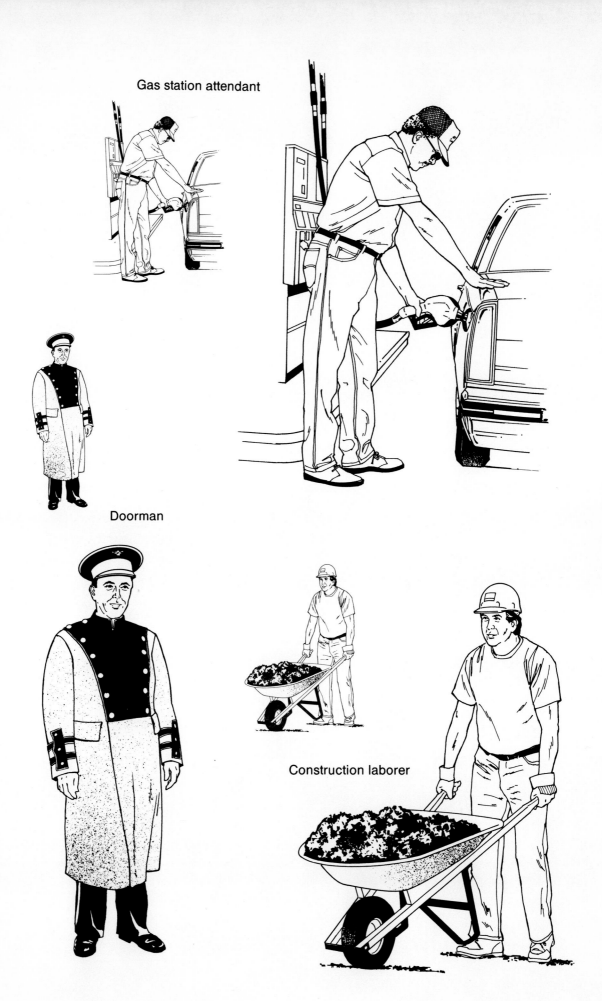

Doorman

Construction laborer

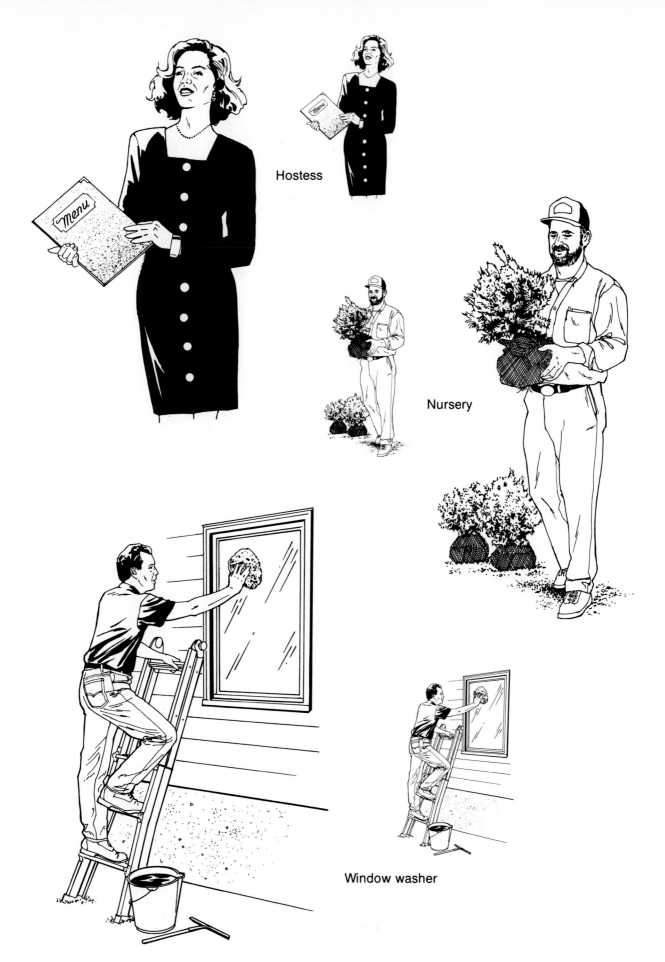

Hostess

Nursery

Window washer

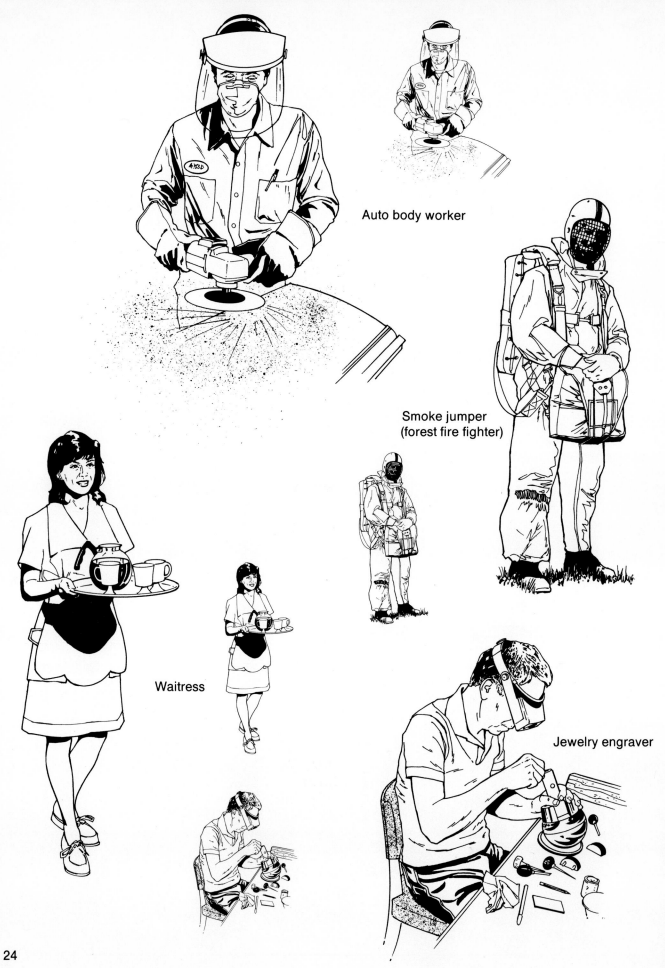

Auto body worker

Smoke jumper
(forest fire fighter)

Waitress

Jewelry engraver

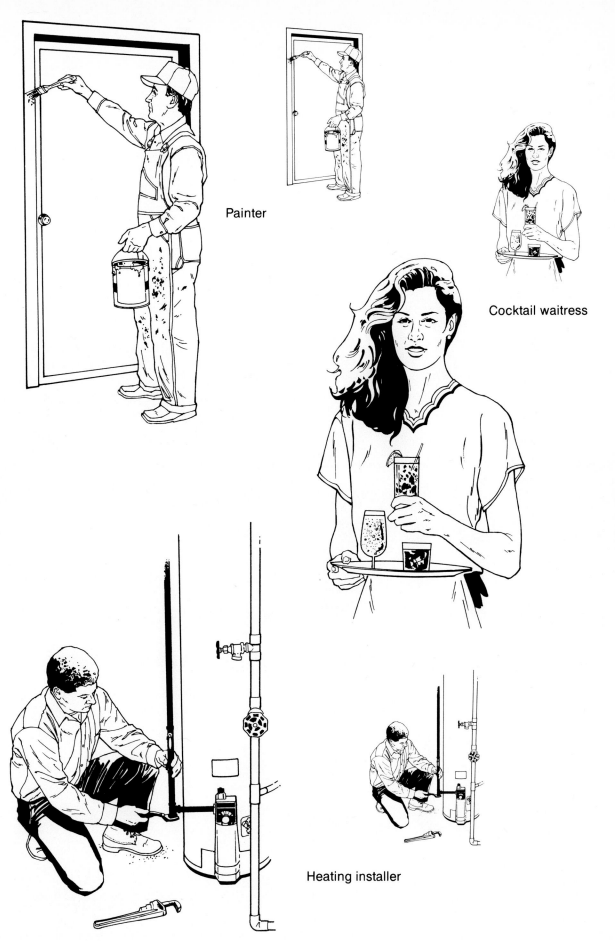

Painter

Cocktail waitress

Heating installer

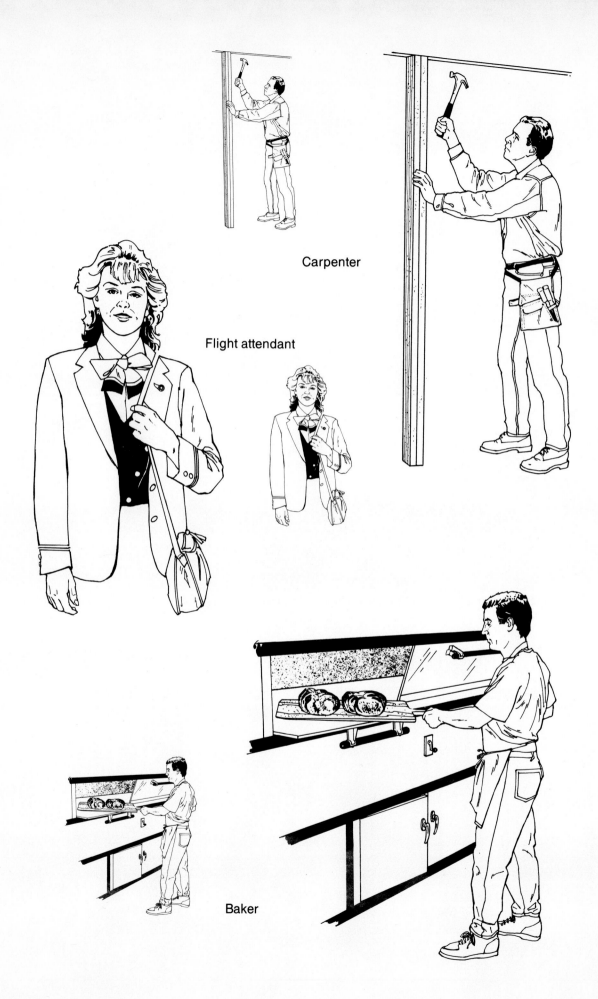

Carpenter

Flight attendant

Baker

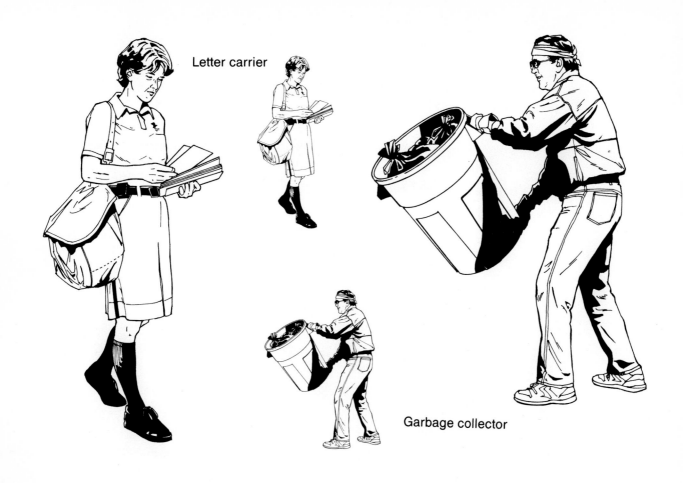

Letter carrier

Garbage collector

Plumber

Bricklayer

Security guard

Waiter

Wallpaper hanger

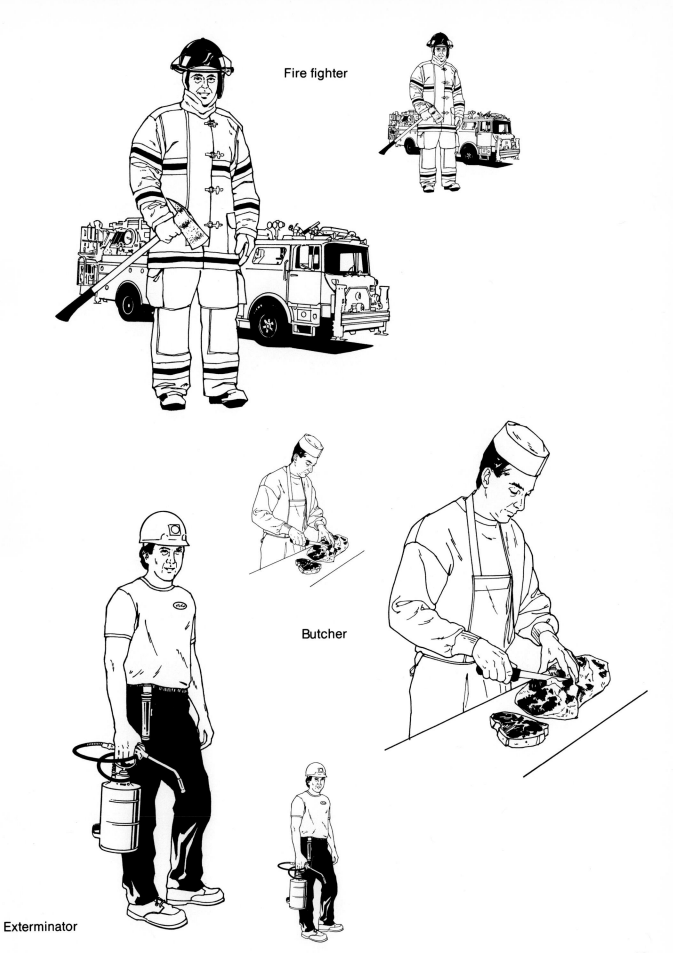

Fire fighter

Butcher

Exterminator

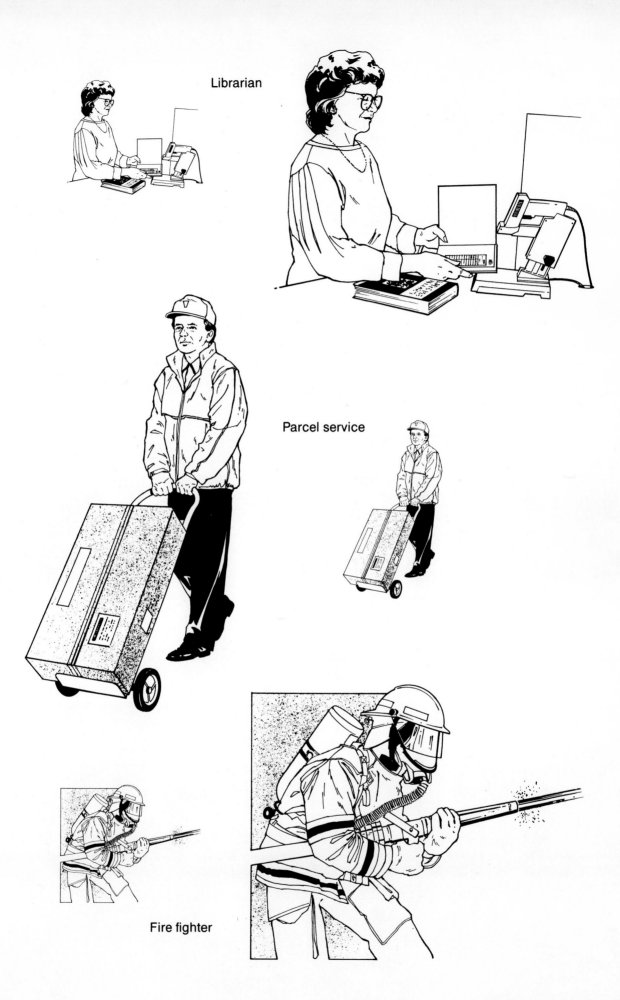

Librarian

Parcel service

Fire fighter

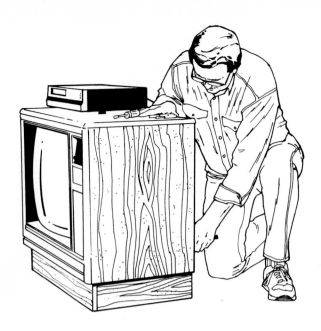

TV repair

Train conductor

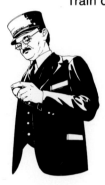
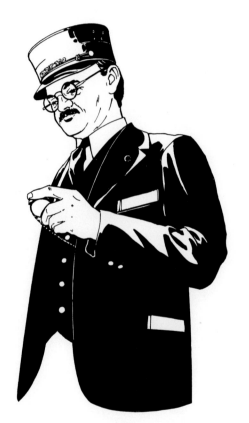

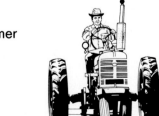

Farmer